Nombre: _____________________

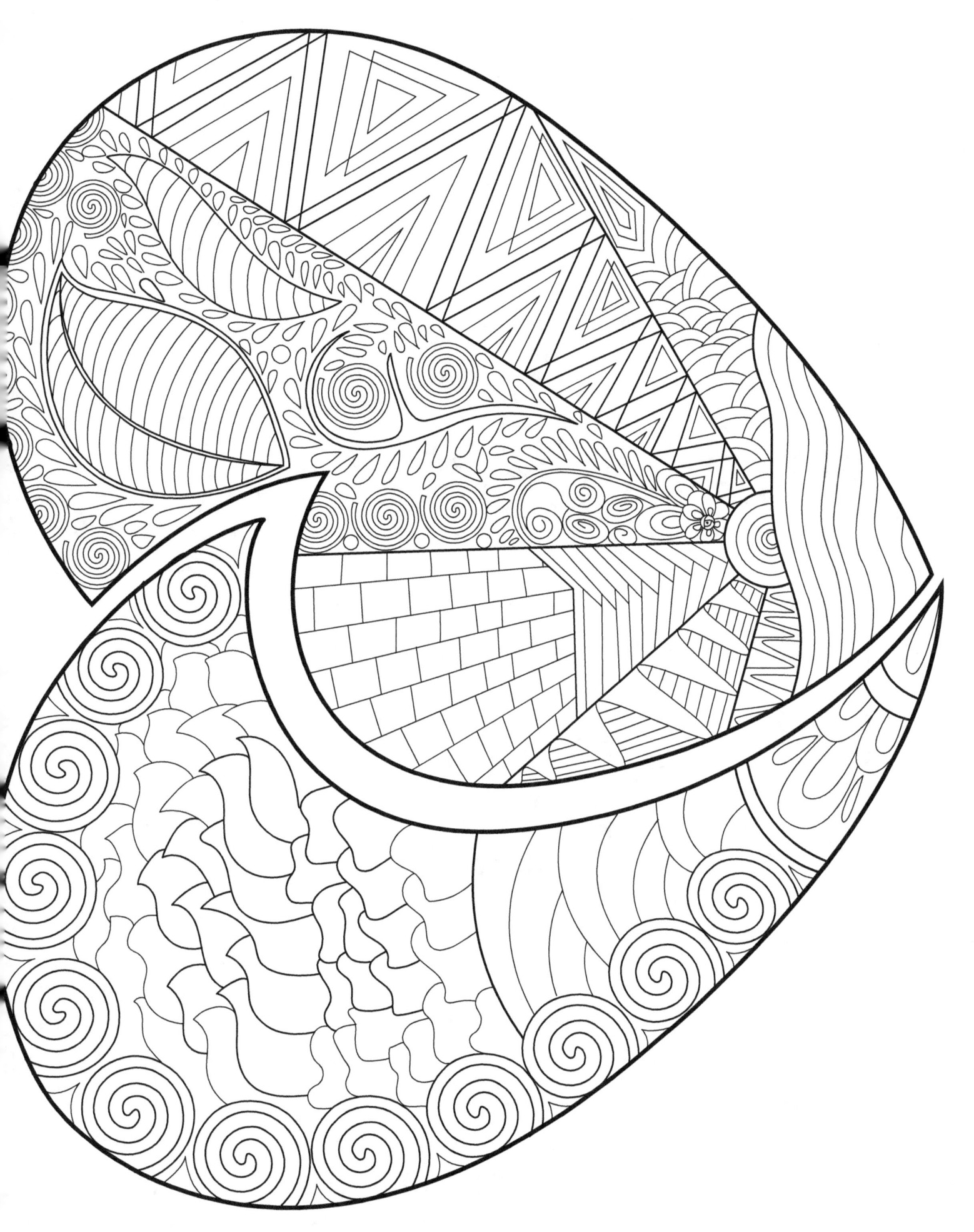

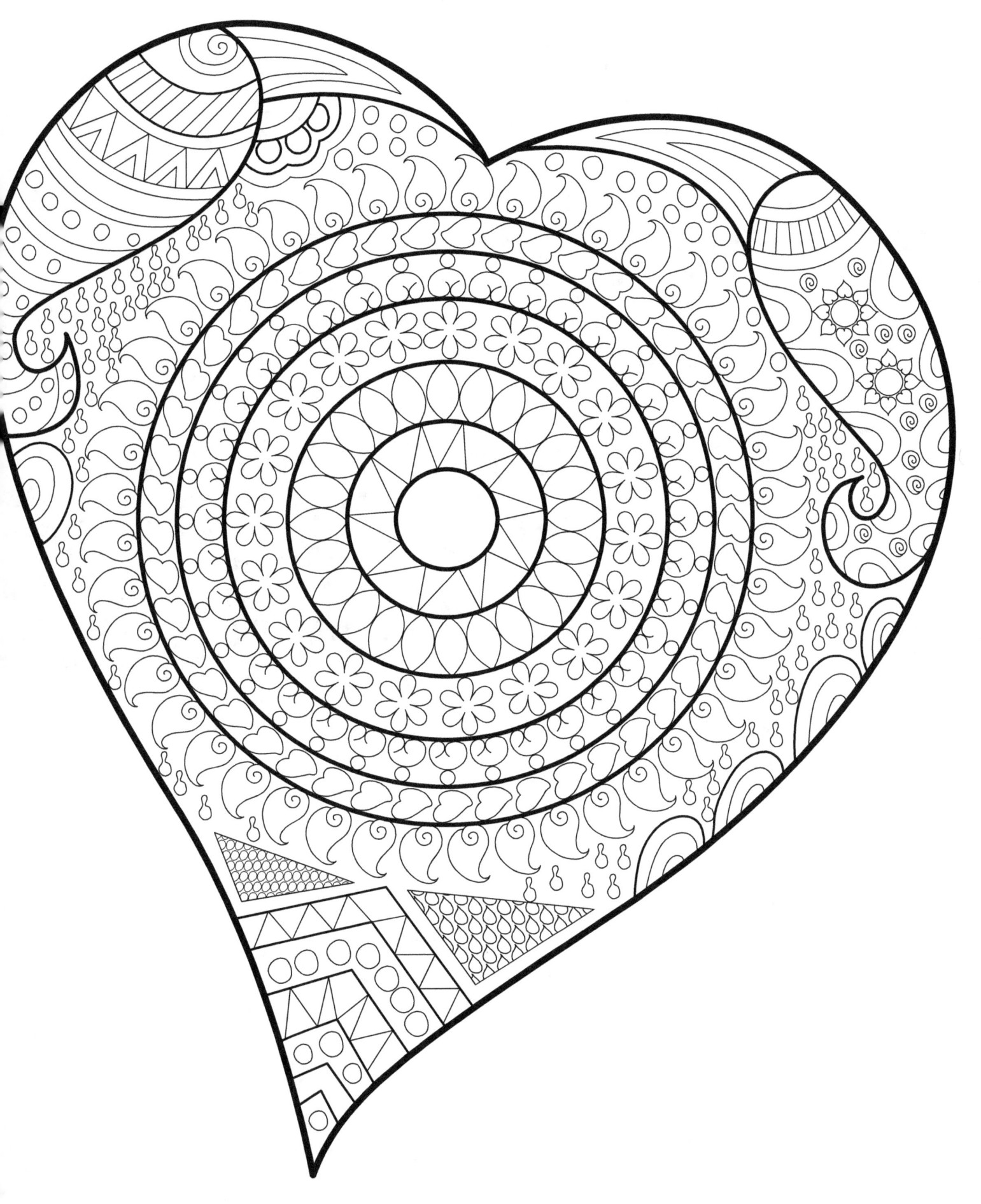

Laberinto

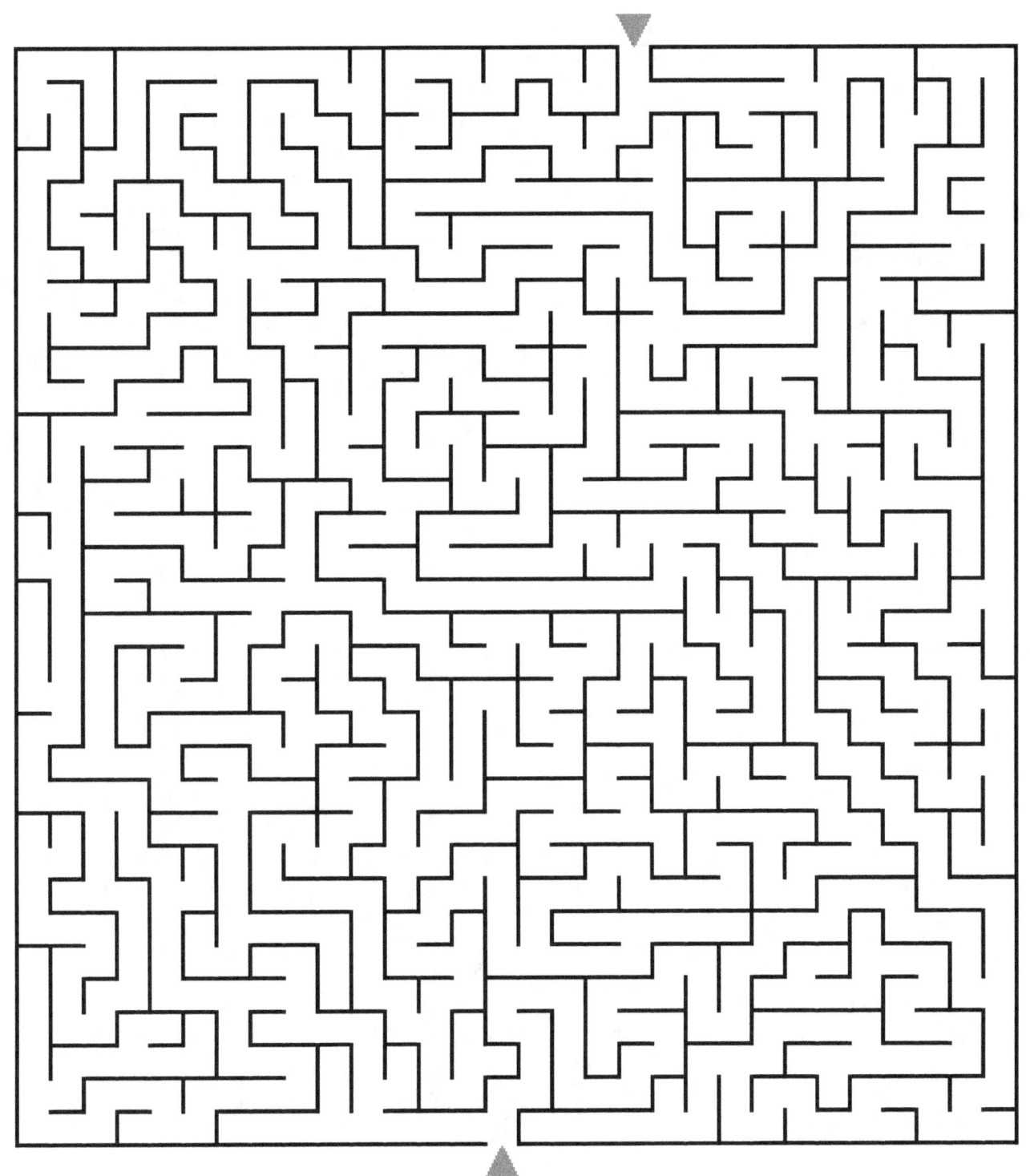

Tablas de Colores

Solución del laberinto

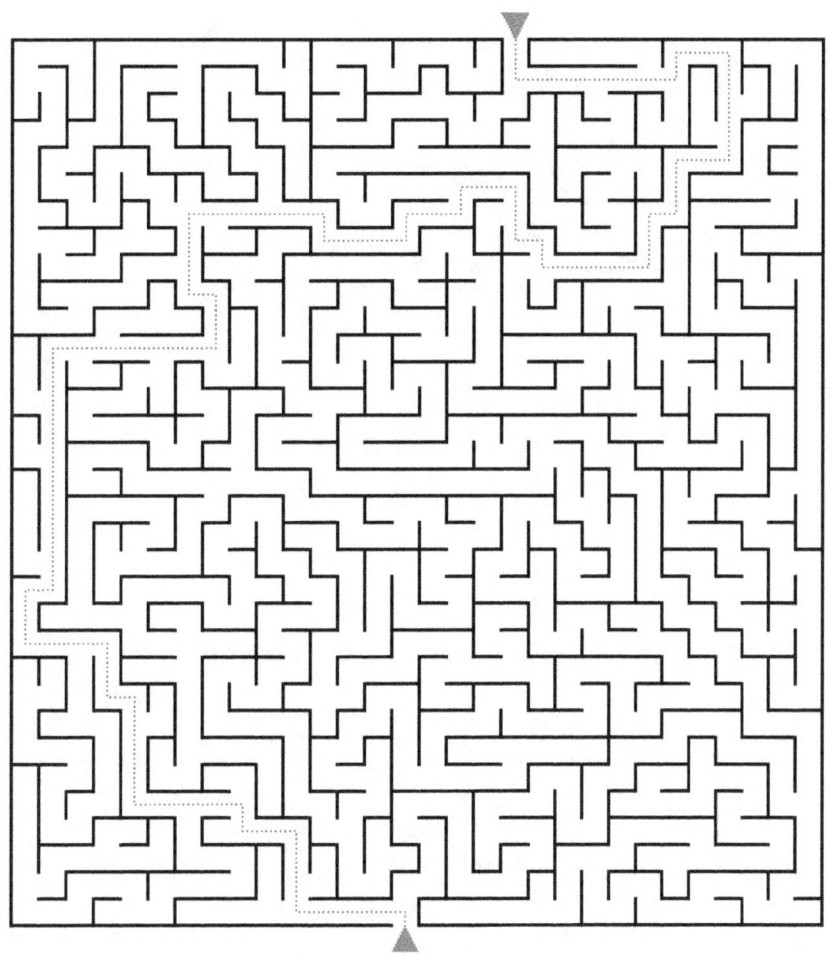

www.ingramcontent.com/pod-product-compliance
Lightning Source LLC
Chambersburg PA
CBHW081452220526
45466CB00008B/2612